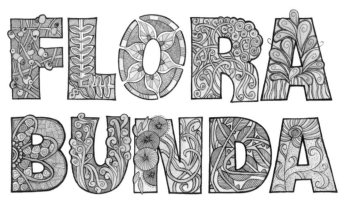

FLORA BUNDA

BY C.C. SADLER, CZT, LETTERINGANDTANGLING.SQUARESPACE.COM

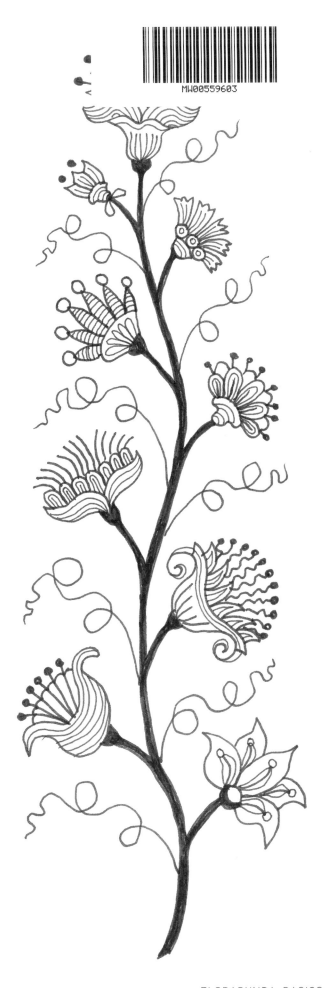

Picture yourself walking in a garden. Can you smell the flowers? Hear the dew dripping from the leaves? You feel relaxed, peaceful, and joyful.

Now you can recreate that happiness every time you pick up a pen. FloraBunda is a collection of simple, easy-to-draw, nature-inspired art doodles that you can use to create your own unique art. Whether you already love drawing or have never thought of yourself as someone who can draw, you'll find the simple shapes of the flowers, leaves, and vines of FloraBunda easy to learn. Fanciful flowers and whimsical critters flow effortlessly from your hand through your pencil, pen, or marker as you create vibrant gardens that flourish on paper. Embellish backgrounds with wispy tendrils and delicate seedpods. Bring your art to life with buzzing bees, fluttering butterflies, and friendly critters. Personalize your work with embellished monograms, alphabets, and initials. Then use markers, colored pencils, watercolors, or any favorite medium to magically transform your inky doodles into exotic, lively plants. Simple steps for drawing are included in this book to get you started.

In no time you'll be creating gorgeous art and watching your garden grow. Best of all, with more than 200 elements to choose from, you'll be able to mix and match patterns to make thousands of fresh combinations, so every piece you draw will be uniquely yours. It's time to abundantly bless your creativity with FloraBunda.

Blooms Border

Embellish a simple stem with a variety of blooms, then add twining tendrils.

BASIC DRAWING

Follow these simple steps to turn lines into fabulous shapes. Pens and markers are available in a variety of tips for different purposes. The .005 is the thinnest line for adding delicate details. An .05 is good for drawing outlines, an .02 for adding details, and an .08 for filling in black areas. Experiment with all the sizes to find what works best for you. Brush markers are an option, too, for adding thickness and texture to lines.

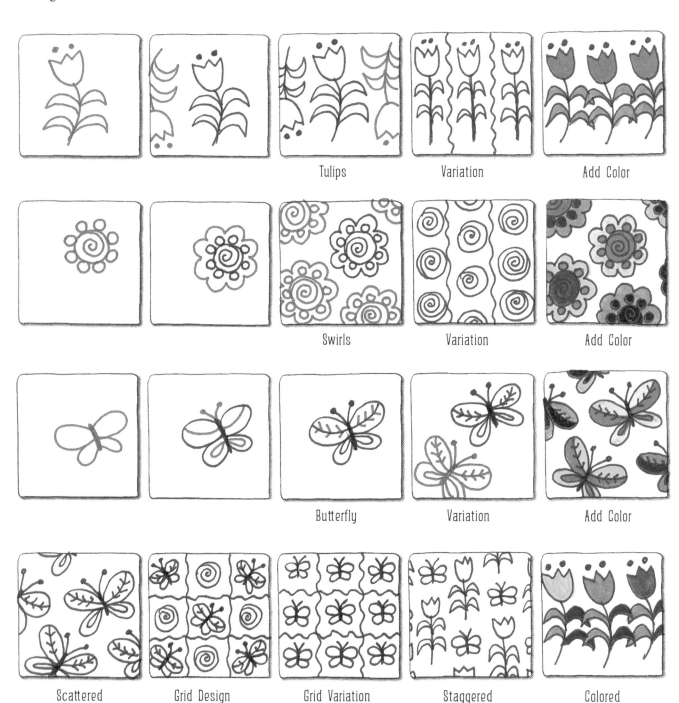

| | | Tulips | Variation | Add Color |

Swirls · Variation · Add Color

Butterfly · Variation · Add Color

Scattered · Grid Design · Grid Variation · Staggered · Colored

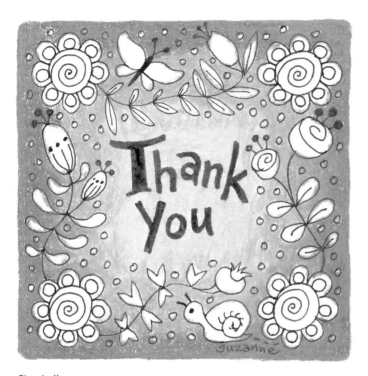

Thank You
An attitude of gratitude leads to a happy life. Draw flowers with an .01 MICRON pen. Write "Thank You" in the center. Use Prismacolor pencils to color the background.

INSPIRED BY NATURE
Nature brings joy to our lives. Blooms, leaves, stems, and insects entertain and find their way into art. Color adds beauty, bringing vibrant petals to life. Calming green leaves and a variety of blooms invite us to relax. Drawing simple patterns allows us to create an inky doodle garden as a respite for the soul. Simple doodles and patterns rejuvenate your creativity. Enjoy the variation in FloraBunda.

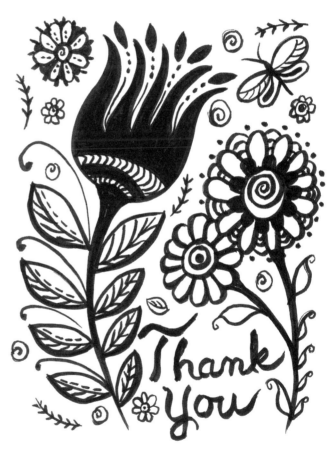

Black and White Thank You
This thoughtful sentiment with bold flowers was drawn with brush markers.

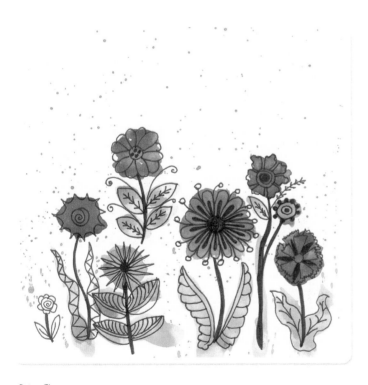

Drip Flowers
Create fun and easy flowers on a variety of colored drips. Drip large watercolor drops onto cardstock. Let dry. Draw designs with an .05 black MICRON pen.

Black Pens

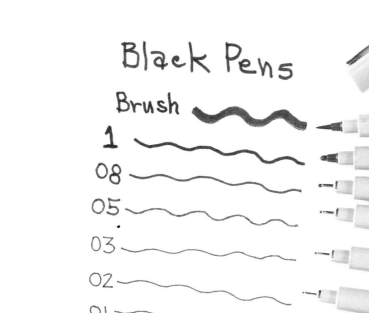

Brush

1

08

05

03

02

01

005

Adding Details

and Tangles

Black Pens. Draw sample lines with different pen tips. Practice marking with MICRON or PITT pens to draw inky designs for your garden. An .05 pen is good for drawing outlines, an .02 pen for adding details, and an .08 pen for filling in black areas. Experiment to find what sizes work best for you.

Add Details
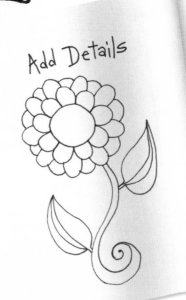

to Designs
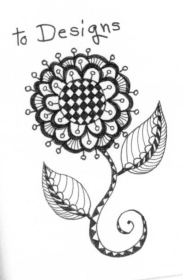

Adding Details and Tangles. Experiment with pen sizes to discover what you like. It also gives you an opportunity to practice.

Add Details to Designs. An outlined flower is beautiful, but it's more beautiful when pattern details are added to the spaces. Use an .05 pen to outline, an .02 pen for details, and an .08 pen to fill black spaces.

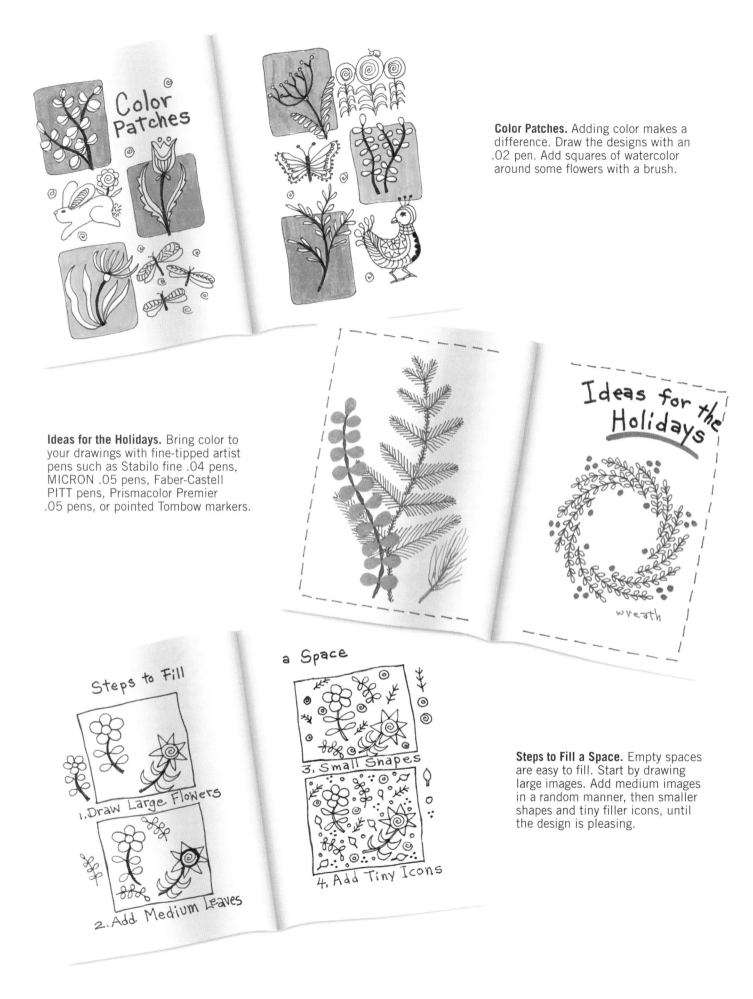

Color Patches. Adding color makes a difference. Draw the designs with an .02 pen. Add squares of watercolor around some flowers with a brush.

Ideas for the Holidays. Bring color to your drawings with fine-tipped artist pens such as Stabilo fine .04 pens, MICRON .05 pens, Faber-Castell PITT pens, Prismacolor Premier .05 pens, or pointed Tombow markers.

Steps to Fill a Space. Empty spaces are easy to fill. Start by drawing large images. Add medium images in a random manner, then smaller shapes and tiny filler icons, until the design is pleasing.

FRAMED ART

Art is one of the most personal gifts. It is a sharing of yourself. The joy you feel when you draw doubles when it's shared. Be inspired to embellish with your own hand, your imagination, and your inky doodles. Imagine a loved one opening a birthday envelope to discover a garden of heartfelt wishes.

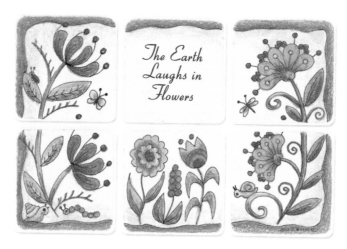

The Earth Laughs in Flowers

Celebrate the joy of living as your creativity blossoms. Draw flowers on six 2" (5cm) paper tiles. Color the design and shade the edges with color pencils.

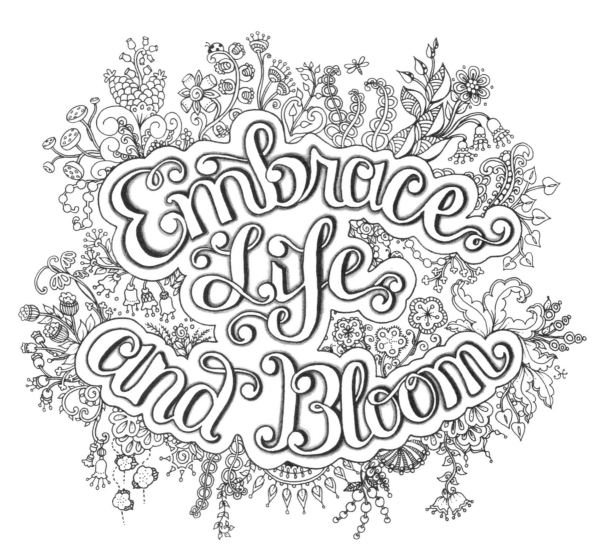

Embrace Life and Bloom
BY SANDY HUNTER, CZT, TANGLEBUCKET.BLOGSPOT.COM

Sandy loves all things artsy, silly jokes, tangling, drawing, and sharing with other artists. Sandy hopes you will embrace your drawing and let it bloom. Start with your own handwriting using an .005 MICRON pen. Add curls where they look good. Add shadows to the lines. Using an .02 pen, darken the lines that are made on the downstroke. Tangle all around with an .005 pen. Add shading around the outer border with a 2B pencil.

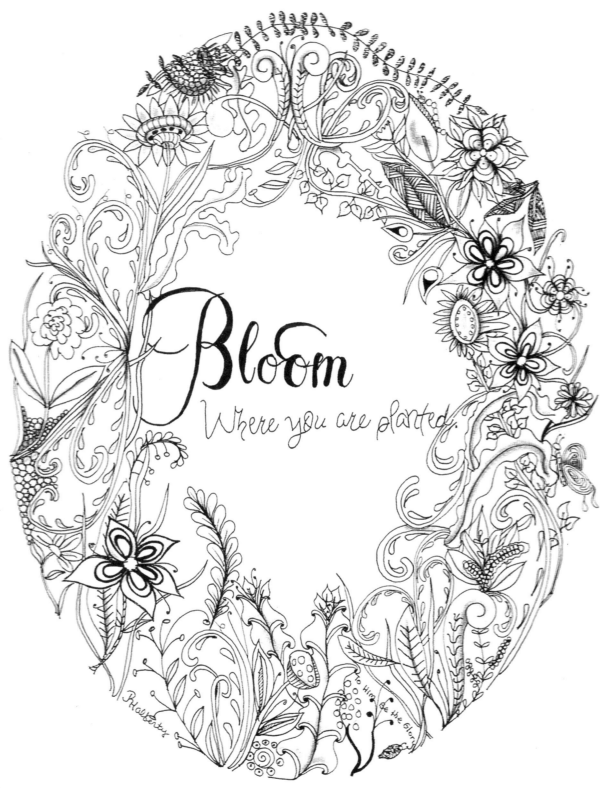

Bloom

BY JODY HALFERTY, CZT, JODYHALFERTY.COM

Jody's designs encompass both the ethereal nature of belief and the strength of spirit. Her leaves, ferns, flowers, and tangles resemble wispy vines to create the perfect look. Trace around an oval to create the center space. For lettering, trace computer-printed words onto Bristol vellum paper using graphite transfer paper. Use an .01 MICRON pen for drawing.

ADDING COLOR

Color brings art to life. Some of my favorite tools for adding color include artist pens, colored markers, colored pencils, and watercolors applied with a brush.

Coloring is half the fun. Applying color is just as relaxing as drawing the design and it is gorgeous when you finish!

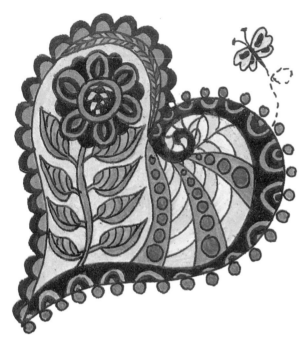

Heart
Draw with an .05 MICRON pen. Fill the spaces with colored pencils.

Bloom
Draw the designs with colors of brush markers (use the tip).

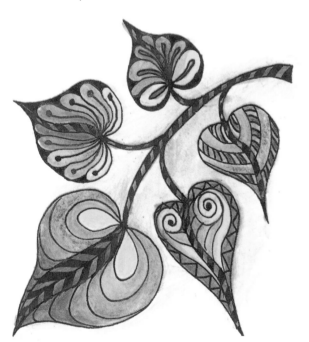

Leaves
Draw with an .05 MICRON pen. Fill spaces with watercolor pencils. Touch the colors with a damp brush.

Bunnies
Draw with an .05 MICRON pen. Use watercolors to tint the background. Add watercolor to the designs.

COLOR

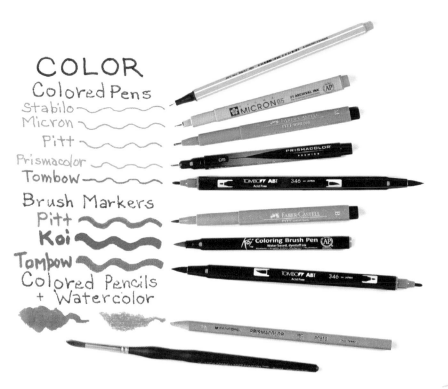

Colored Pens
Stabilo
Micron
Pitt
Prismacolor
Tombow

Brush Markers
Pitt
Koi
Tombow
Colored Pencils
+ Watercolor

Try using colored pens, markers, and watercolors to draw your designs or to color black designs. You'll be delighted at the surprising diversity of the results.

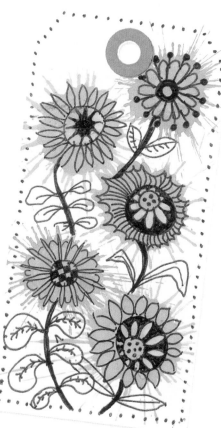

Tag

Drip splats of watercolors on a gift tag and let them dry. Draw flowers on top of the colors with a black .05 MICRON pen.

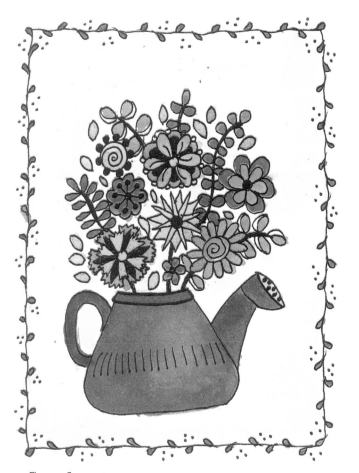

Flower Bouquet

Draw the design with a black .05 MICRON pen. Lightly tint the background and add color with watercolors.

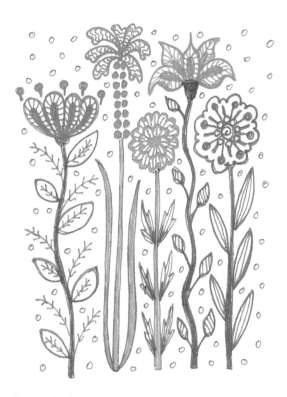

Flower Garden

Draw colorful flowers with fine-tipped .04 Stabilo color pens.

BLOOMS

It's fun to mix and match patterns to create
your own one-of-a-kind flower creations.

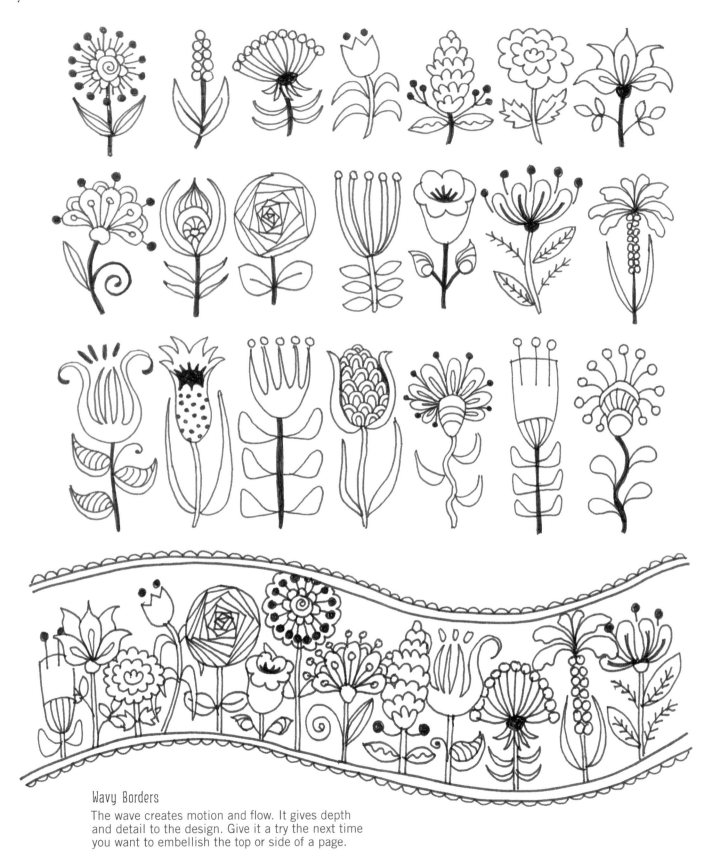

Wavy Borders
The wave creates motion and flow. It gives depth
and detail to the design. Give it a try the next time
you want to embellish the top or side of a page.

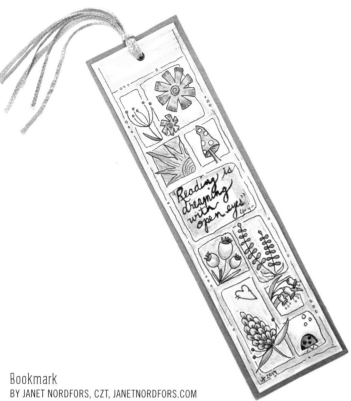

Bookmark
BY JANET NORDFORS, CZT, JANETNORDFORS.COM

This segmented bookmark uses soft pastel colors coordinated with flowering designs to create a lovely effect. To make it, cut a piece of cardstock to 2" x 8" (5 x 20cm). Use a pencil to divide the area into sections. Write a sentiment in one of the sections and add designs and color. Glue the piece to a slightly larger piece of lavender cardstock.

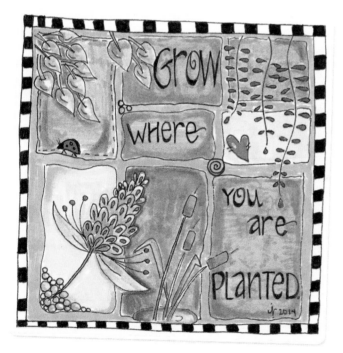

Grow Where You Are Planted
BY JANET NORDFORS, CZT, JANETNORDFORS.COM

You can divide a shape into geometric sections for an organized but still natural effect. First divide the area into sections with a pencil, then write your sentiment with only one or a few words in each section. Then add designs, and color with colored pencils.

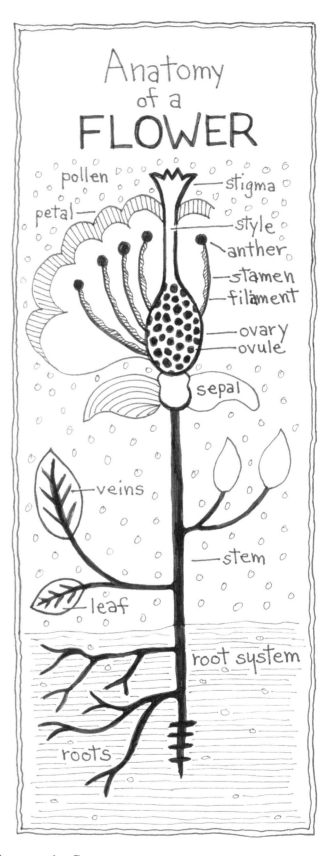

Anatomy of a Flower

Ever wonder what to draw? Your floral designs don't have to be realistic by any means, but by studying the structure of a real flower, you can get ideas of ways to modify designs and create new ones. This drawing was inspired by an old botany book.

VINES

These twining and flowing tendrils make great borders for cards, art, and more.

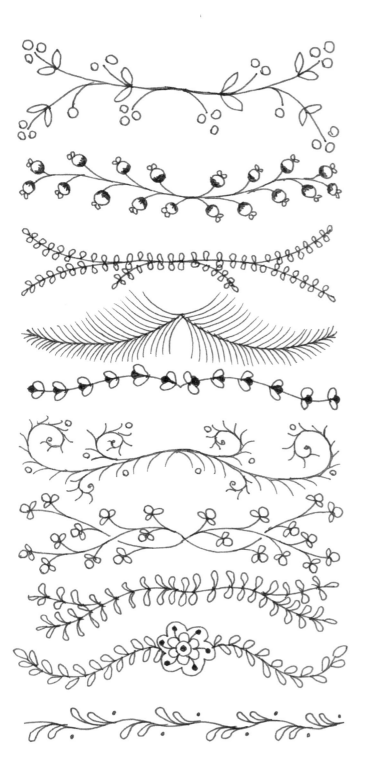

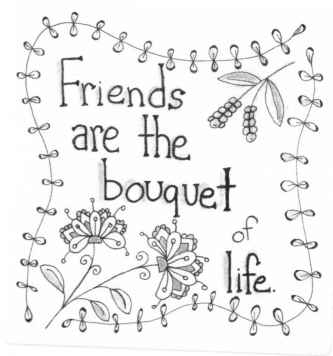

Friends
BY DAWN MEISCH, CZT, ONCEUPONATANGLE.COM

Friends brighten our days just like a fresh bouquet of flowers. For a piece like this, use one type of vine as a border and some larger flowers as focal points. Use an .01 MICRON pen.

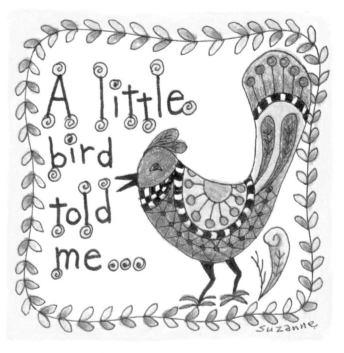

A Little Bird Told Me

Cheerful birds like this one are fun to embellish! Use a MICRON pen to draw the bird and color with Prismacolor colored pencils.

Vine Border
BY C.C. SADLER, CZT,
LETTERINGANDTANGLING.SQUARESPACE.COM

Relax your mind and let your creativity flow as you embellish designs and add beautiful sentiments. You could change the word inside this vine border to make a thank-you card or just a sentiment to post in your office.

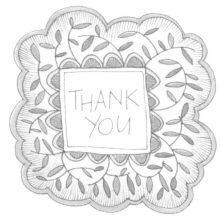

Thank-You Note
BY C.C. SADLER, CZT,
LETTERINGANDTANGLING.SQUARESPACE.COM

It's easy to create thank-you notes in just minutes. Draw a box and write "Thank You" in simple letters in the box with an .01 MICRON pen. Draw a scallop around the box. Draw a large scalloped shape to create a new outer edge to the design, and then fill the space with vines. Shade or color as desired with color pencils.

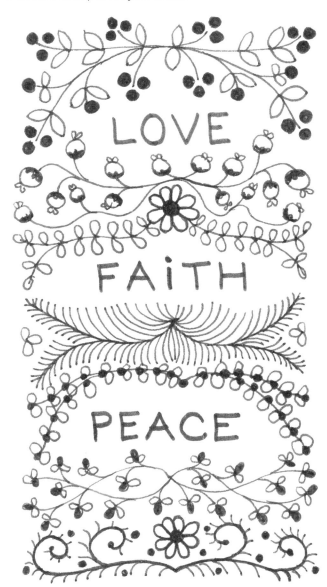

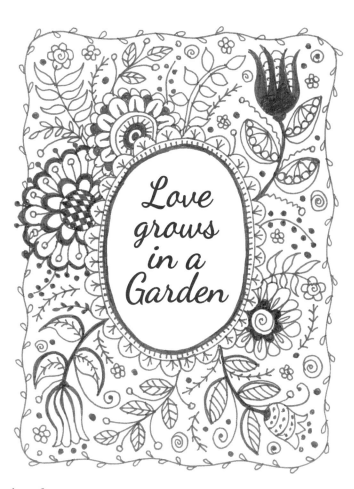

Love Grows
Anyone who has a garden, admires gardens, or observes natural wildflowers in a field knows how peaceful you feel when in a garden.

Love Faith Peace
On smooth watercolor paper, use a fine-tipped pen, like an .05, to draw the vines, and then write words in the spaces with an .08 pen.

PETALS

Create a garden with petals that grow into beautiful works of art.

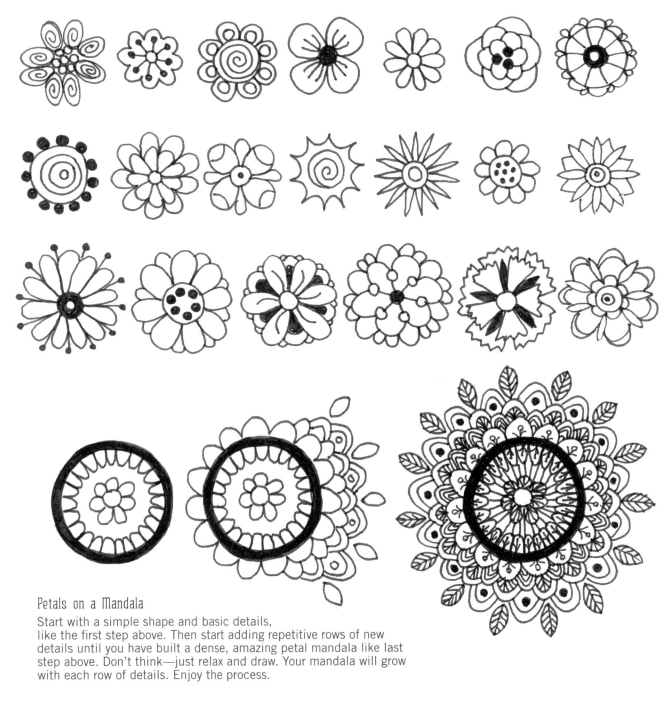

Petals on a Mandala

Start with a simple shape and basic details,
like the first step above. Then start adding repetitive rows of new
details until you have built a dense, amazing petal mandala like last
step above. Don't think—just relax and draw. Your mandala will grow
with each row of details. Enjoy the process.

Mix and Match Petal Patterns

Next time you need inspiration, just
look at all the petal possibilities
shown here. Mix up the patterns to
create your own designs.

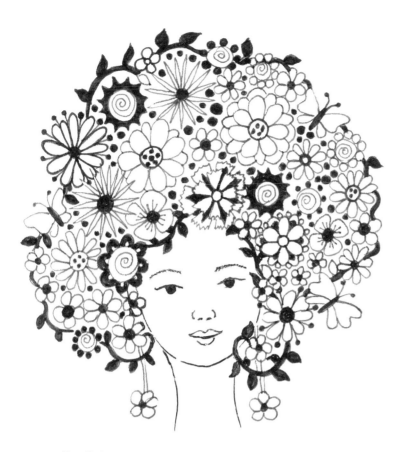

Hair Today

Retro is back in full-blown flower power. Trace a face or draw one and surround it with flowers for hair. This is too much fun to miss!

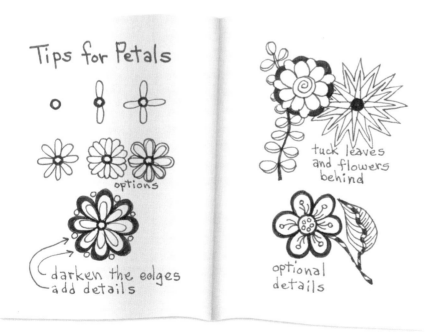

Tips for Petals

options

tuck leaves and flowers behind

darken the edges add details

optional details

Tips for Petals

Create dimension in a design by tucking leaves and stems behind a big flower.

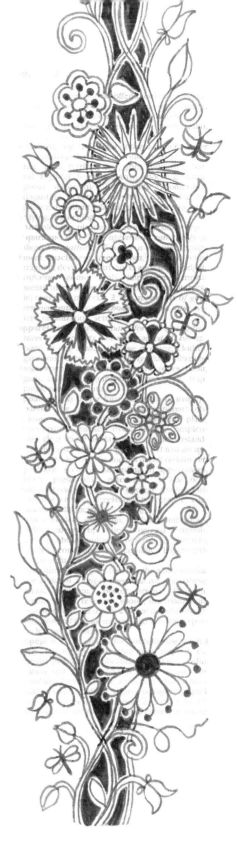

Mixed Media Vine

Rip out a book page and glue it to watercolor paper with Soft Gel Gloss. Prepare a mixture of one half white gesso and one half water. Apply a thin coat over the book page. Let dry, then add designs.

LEAVES

Whether you color them "naturally" in greens and oranges or go fantastical, leaves are an essential part of nature designs!

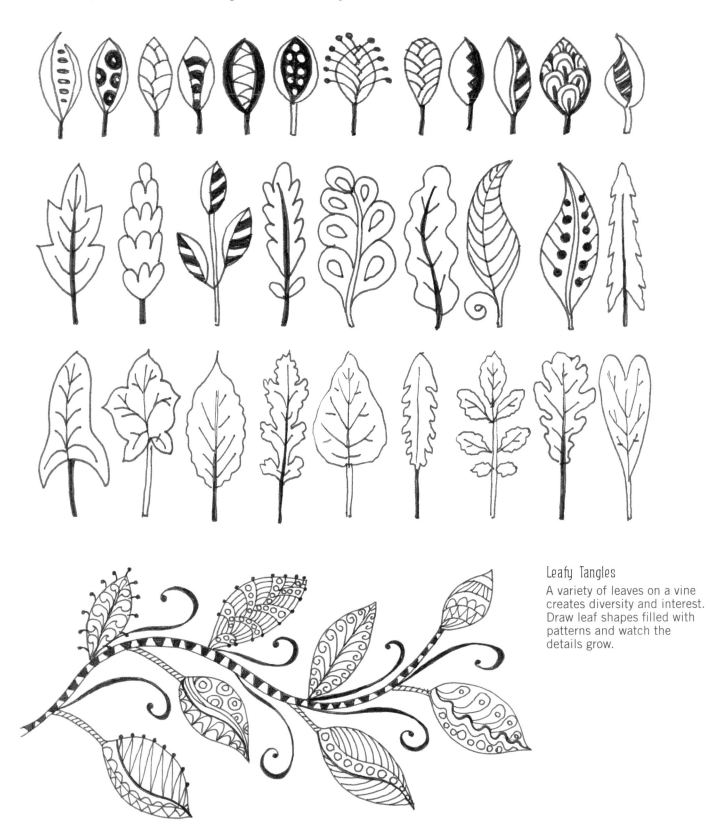

Leafy Tangles

A variety of leaves on a vine creates diversity and interest. Draw leaf shapes filled with patterns and watch the details grow.

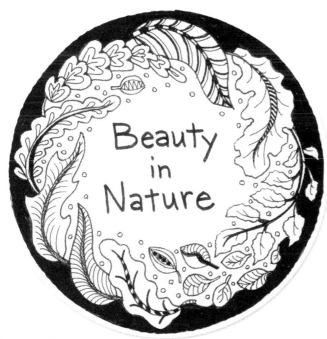

Beauty in Nature

The wonderful thing about circles is that you don't have to plan out the design. Just relax and let your hand create leaf shapes as you go around the circle. Turning the paper as you go makes it easier.

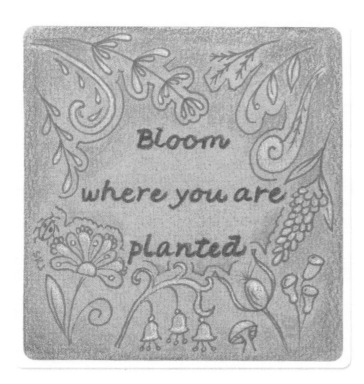

Bloom Where You Are Planted
BY SUE JACOBS, CZT, SUEJACOBS.BLOGSPOT.COM

Sue loves adding color. Choose a colored paper tile and draw designs with a pen of a similar color to the tile. Use Prismacolor pencils in colors for shading and in white for highlights. Note: Sue's colorful tiles can be purchased on her blog.

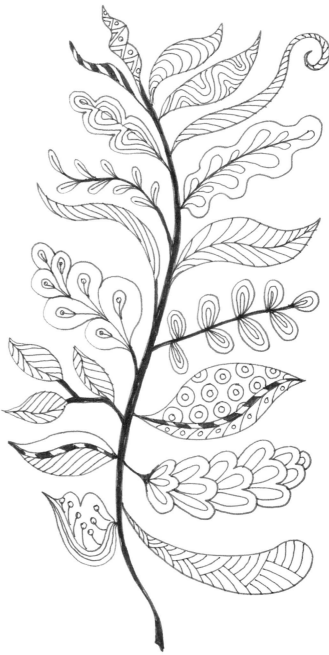

Wispy Frond

So many leaves, so little time! You never realize how many different shapes of leaves there are until you start looking closely. If you'd rather stay in your office, just do a computer search for leaf images. The abundance of leaves on the planet is amazing—it inspired this frond.

PODS

Discover an amazing assortment of pod shapes
flourishing with nature's plenty.

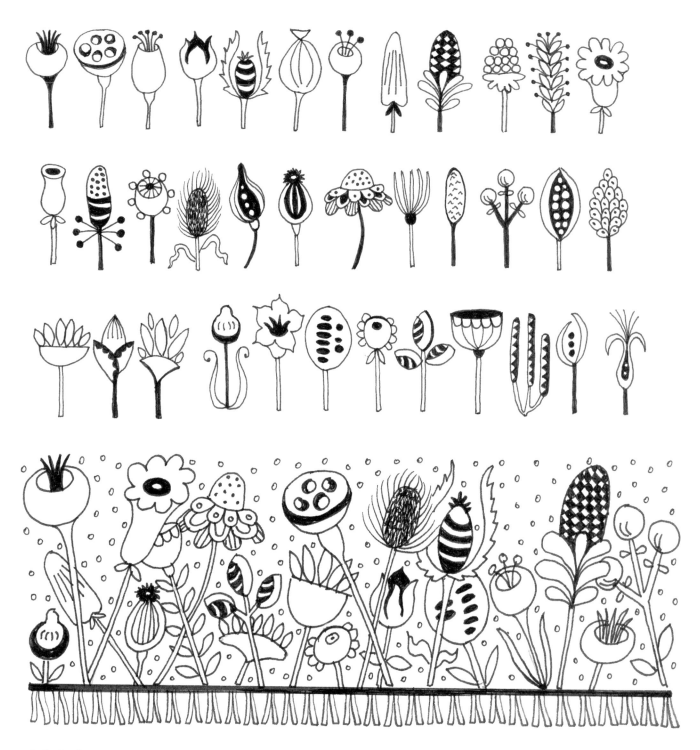

Pods Border

Pods are the seed source of a flower. They come in an abundant variety,
so have fun experimenting. Give your plants a wild look by overlapping
the layers, crowding some together, and making some tall and others
short. Add a background with tiny circles of seeds blowing in the wind.

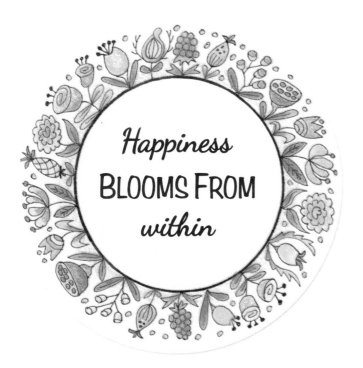

Happiness Blooms from Within

Curves are appealing to the eye. Draw a delicate flowery border. Color the blooms with Prismacolor pencils.

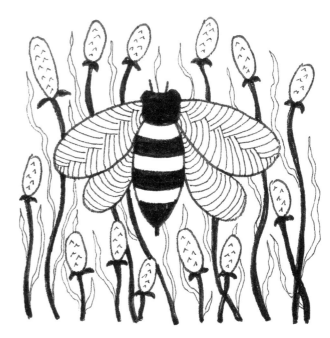

Honey Bee

You'll be happily buzzing as you add details to one of the busiest of nature's creations. Fill the background with stems topped with pollen-bearing pods and your bee will be happy, too.

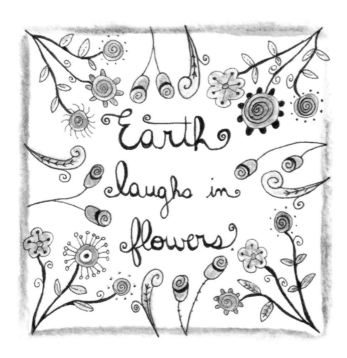

Earth Laughs in Flowers
BY DAWN MEISCH, CZT, ONCEUPONATANGLE.COM

Dawn loves this quote. It is so appropriate for a flower design. Use Inktense watercolor pencils to color the design.

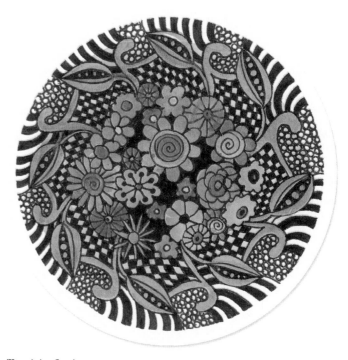

Mandala Garden

This dense design gives the impression of endless growth. Draw an inner circle with a pencil. Fill the border with patterns and turn the paper, filling in the center with leaves. Add color with watercolors.

GROWTH

Drawing creeping tendrils, unfurling ferns, and glorious
growing things can rejuvenate your creativity.

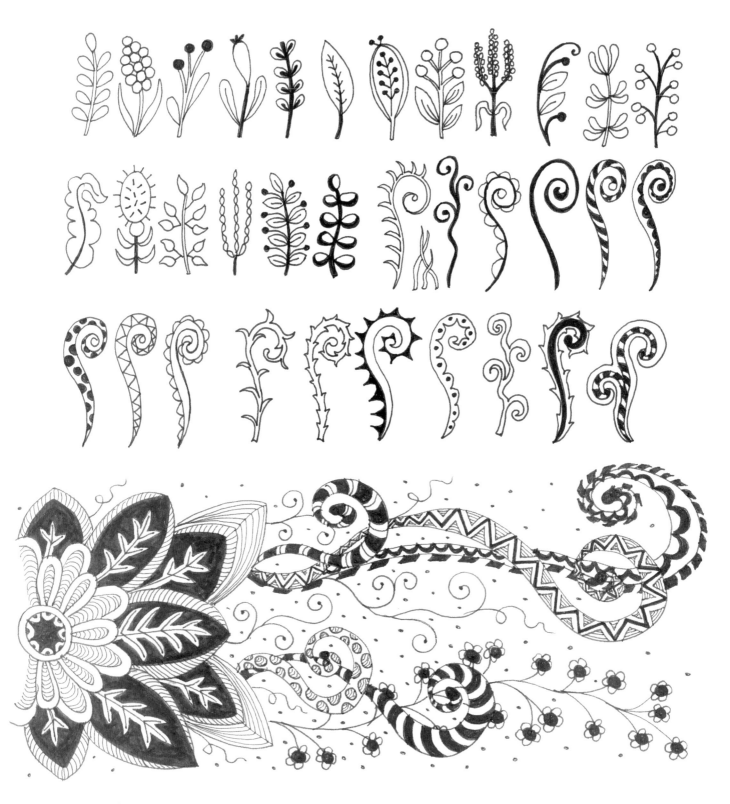

Flower and Ferns
Nature spices her flora with tiny bits of elegant wisps,
delicate tendrils, and prickly spines.

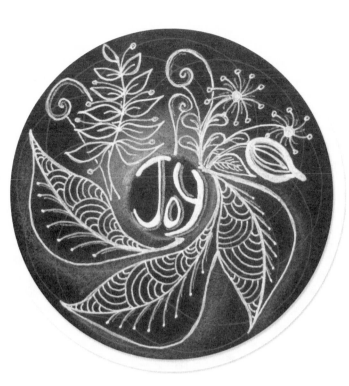

Joy
BY BARB ROUND, CZT, BARBROUNDCZT.WEEBLY.COM

White ink on black creates a perfectly peaceful, frosted look. Write a word in the center of a circular black paper tile with a white gel pen such as Sakura's Gelli Roll pen. Draw designs around the word.

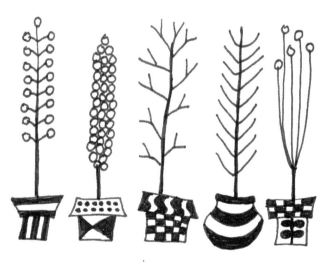

Pots and Plants
Picture yourself on your deck or patio and turn your imagination loose as you draw enough potted plants to fill a garden shop. Each pot offers an opportunity to showcase your favorite Zentangle tangles or patterns.

Garden Border
A black background makes these designs really pop. Try this on a scrapbook page, as framed art, or as a greeting card.

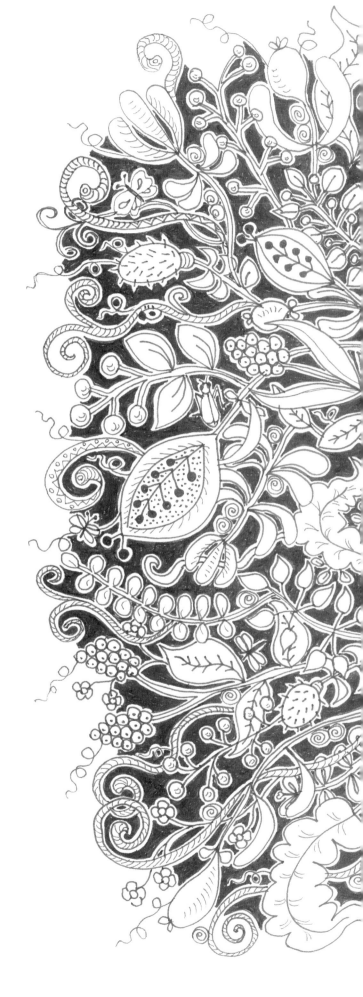

BUDS

Buds are delightful accents on flowers. Tuck them into small spaces or let them peek out from behind leaves.

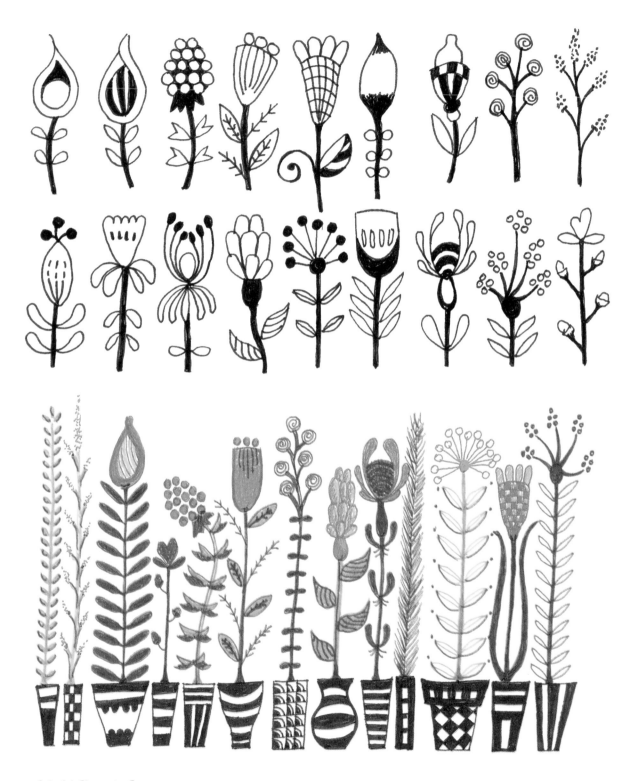

Colorful Plants in Pots
Using colored fine-tipped pens, it is fun to create a beautiful garden of tall potted plants. Draw the pots with a black pen.

BELLS

Many flowers have bell-shaped parts, like pitcher plants, dogbane, twinflower, corncockle, and bluebells—just to name a few.

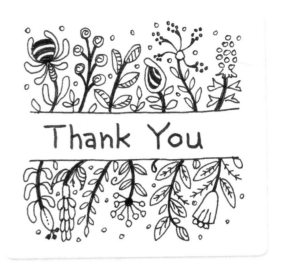

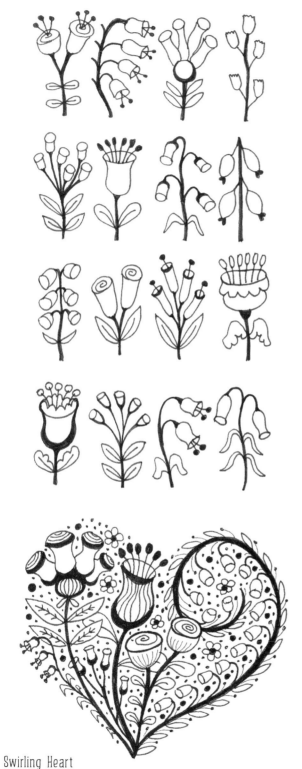

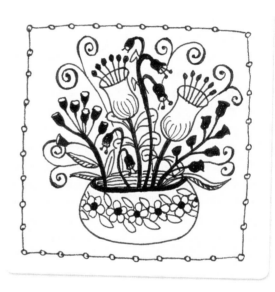

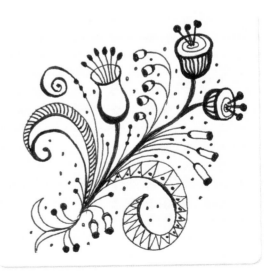

Swirling Heart
Use your imagination and have fun with bell-shaped flora. This heart was drawn with .05 and .08 pens.

Sentiments, Pots, and Bouquets
There are many ways to use flowers—as filler in a background, showcased in pots, or simply as the focal point.

ACCENTS

What's flora without some fauna? Welcome all species of charming creatures into your art.

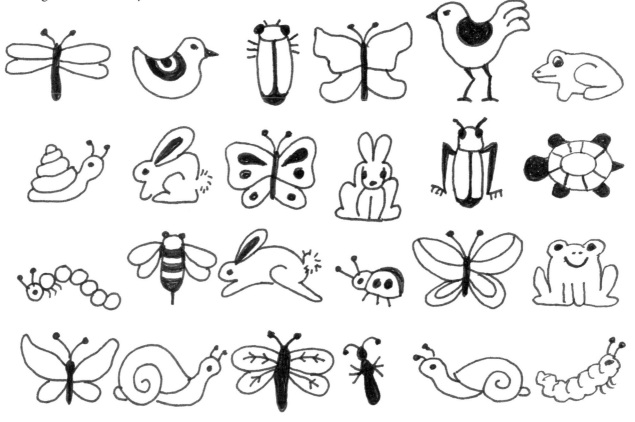

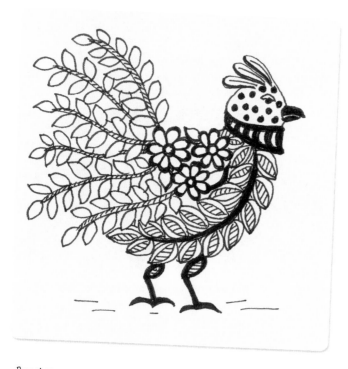

Rooster
Look closely at this rooster. The feathers are actually vines with leaves—what fun!

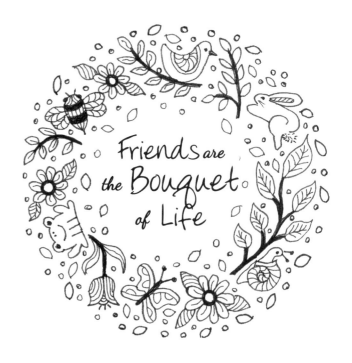

Nature Mandala
Turn your paper as you work to make drawing critters, flowers, and leaves easy.

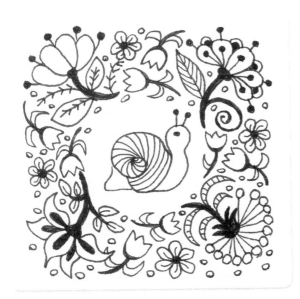

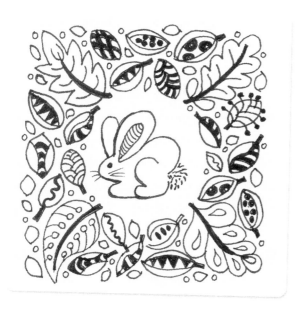

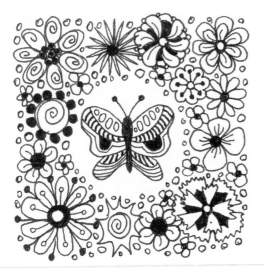

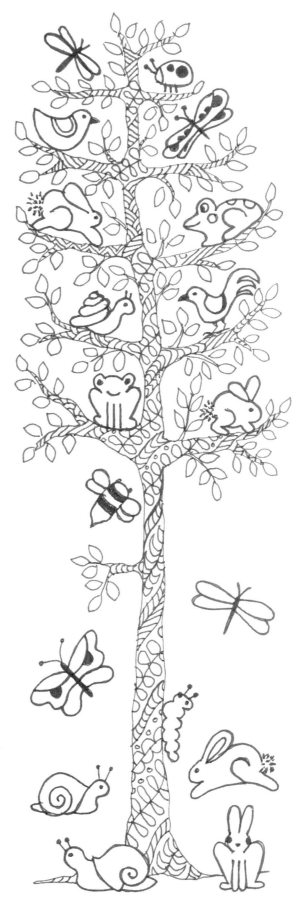

Flower Frames

So sweet! Square tiles make a nice self-contained space to fill with designs and a central accent. Draw a critter in the center. Create a border with flowers, pods, leaves, and petals.

Tree of Life

Draw a tree with many branches and leaves. Add animal accents just for fun.

LETTERS AND ALPHABETS

You can use FloraBunda designs to decorate both standalone letters and entire alphabets.

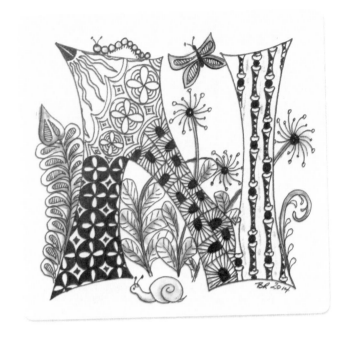

DECORATED MONOGRAM

BY BARB ROUND, CZT, BARBROUNDCZT.WEEBLY.COM

Everyone likes to see their initials, especially when they are emblazoned with hand-wrought embellishments. Elegant letters can be awesome art with versatile gift-giving possibilities. This densely detailed monogram uses Zentangle tangles and FloraBunda design elements for embellishment.

1. Draw a basic letter with a pencil.

2. Draw an outline to create blocky letter.

3. Trace the outline with a pen and erase the basic letter pencil lines.

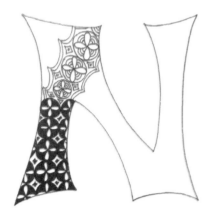

4. Start to draw tangles in the letter.

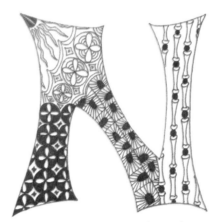

5. Fill the entire letter with tangles.

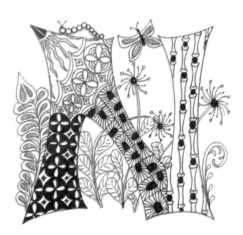

6. Draw FloraBunda designs in the background of the letter.

ALPHABETS TO EMBELLISH

Decorate, embellish, outline, and expand a printout of computer alphabet fonts to create beautiful custom lettering. Start by printing out your favorite computer font; an outline font works best. Then just add flowers and leaves!

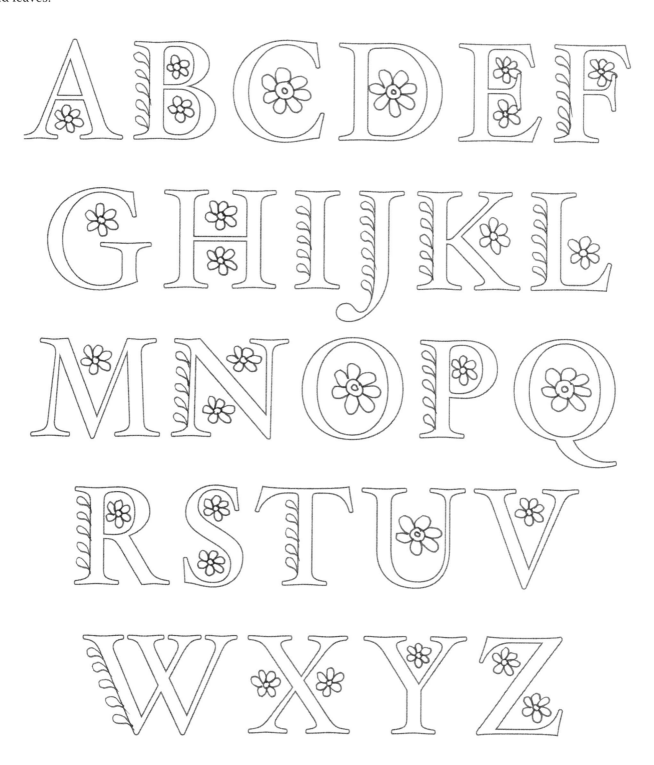

Simple flowers and petals make this alphabet quick and easy.
(Font used: Hoefler Text, Outline)

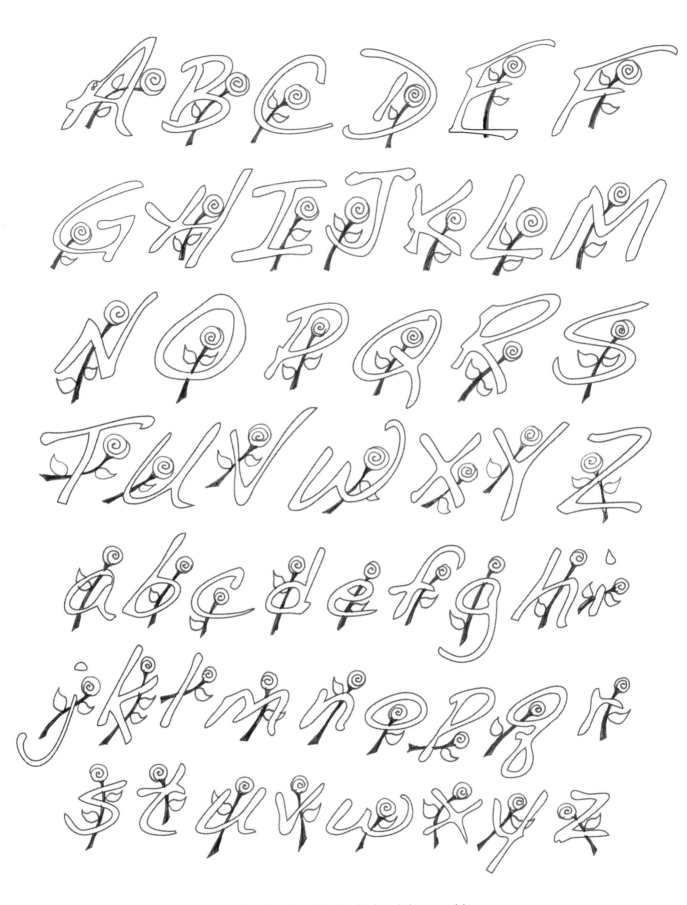

This elegant font is embellished with hand-drawn swirl roses.
(Font used: Dakota Handwriting, Outline)

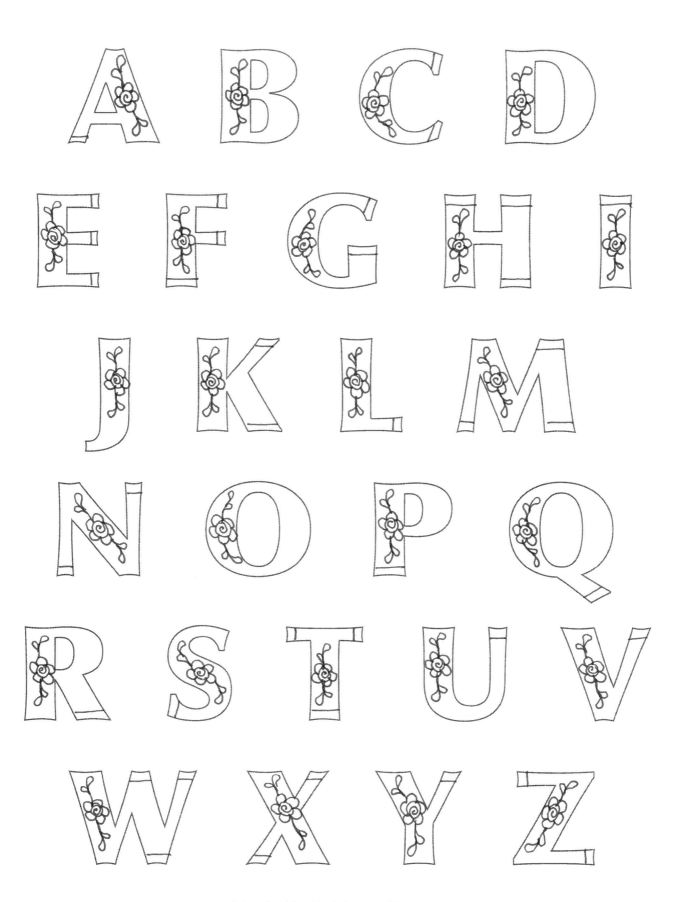

Adorn familiar block letters with elegant roses.
(Font used: Optima ExtraBlack, Outline)

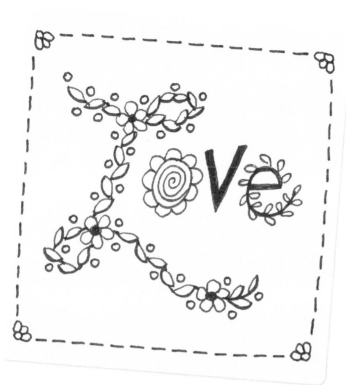

Love

You can use the elements of FloraBunda to create simple, meaningful messages with a black pen. For this word, start by lightly drawing a large cursive "L" with pencil. Using a black pen, outline the letter with leaves, dots, and small flowers. Draw a flower for the lowercase "o." Erase the pencil marks.

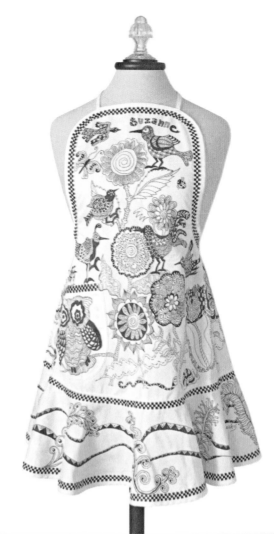

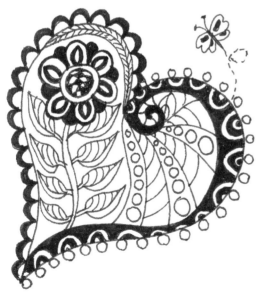

Heart

Draw the outline of a heart with a large flower inside. Draw details, patterns, and a butterfly.

FloraBunda Apron

I was inspired to draw flowers, birds, and tangles on this store-bought canvas apron in 2010. I wore the apron to Quilt Market. It inspired me to create more patterns for this book. I recommend a black Pentel Gel Roller for fabric to draw on canvas or fabrics.

FLORABUNDA BASICS
WORKBOOK

Welcome to the *FloraBunda Basics* workbook section! This workbook is meant to be your space to explore the FloraBunda designs and enjoy letting them flow from your pen. Open your imagination and let the prompts and ideas inspire your creative spirit. You'll see delightful ways to draw interesting flowers, plants, and critters. You can even take this book outside to sketch—nature itself is an endless source of inspiration. With more than 200 patterns to choose from, you can mix and match combinations so you never run out of exciting possibilities.

These pages have a lot of space on them because you'll need it to let your creativity flow. Don't feel limited by what's on the page, either—you don't have to follow the exercises if you have ideas of your own! This is your place to play, experiment, and create.

So go ahead, draw a garden, add some pods, toss in some leaves, and twine a few vines. Let the organic lines of FloraBunda inspire you, and have fun.

HAPPY DRAWING!

DRAW-IT-YOURSELF DESIGNS

This exercise shows you just how simple it really is to draw even seemingly complicated designs. Each design is broken down into several straightforward steps that you can follow to build the completed design quickly and easily. Practice the steps in the squares provided, and learn to see the component parts in each design.

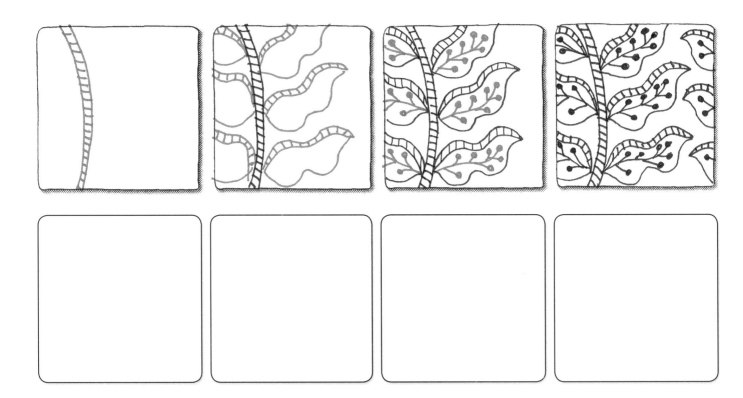

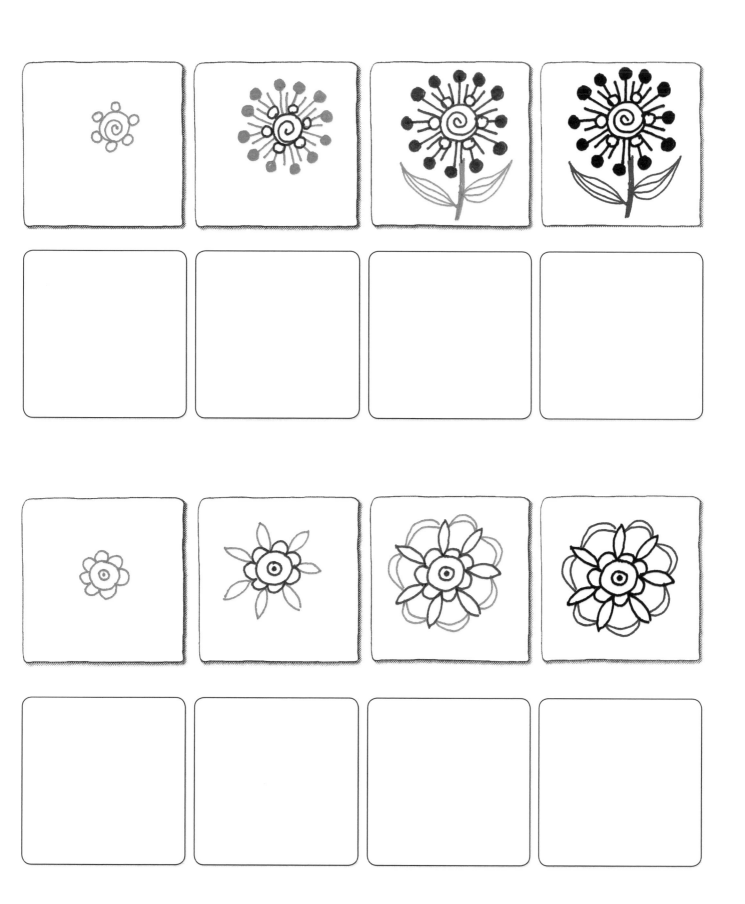

FILL THE SHAPES

Draw designs in these empty shapes to bring them to life. Whether you fill them with a repeating pattern or a more complex composition, they will look intriguing and beautiful. You can also add color if you feel like it.

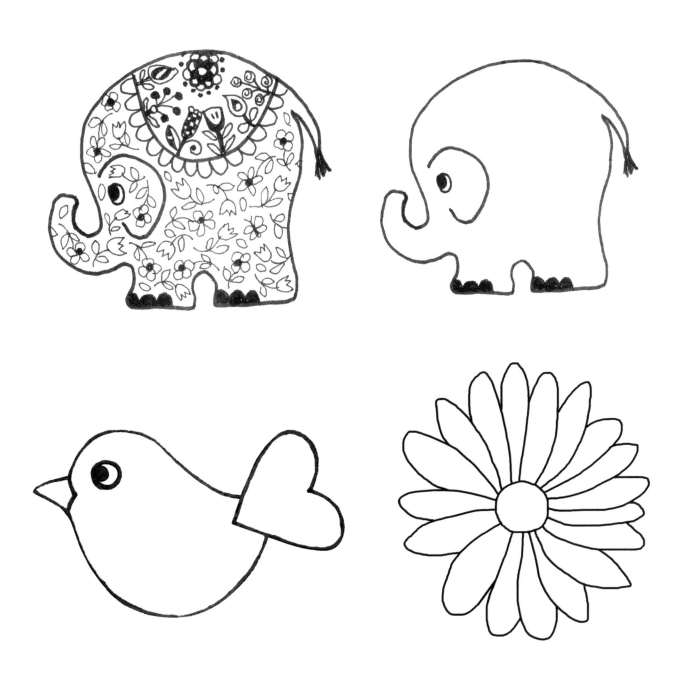

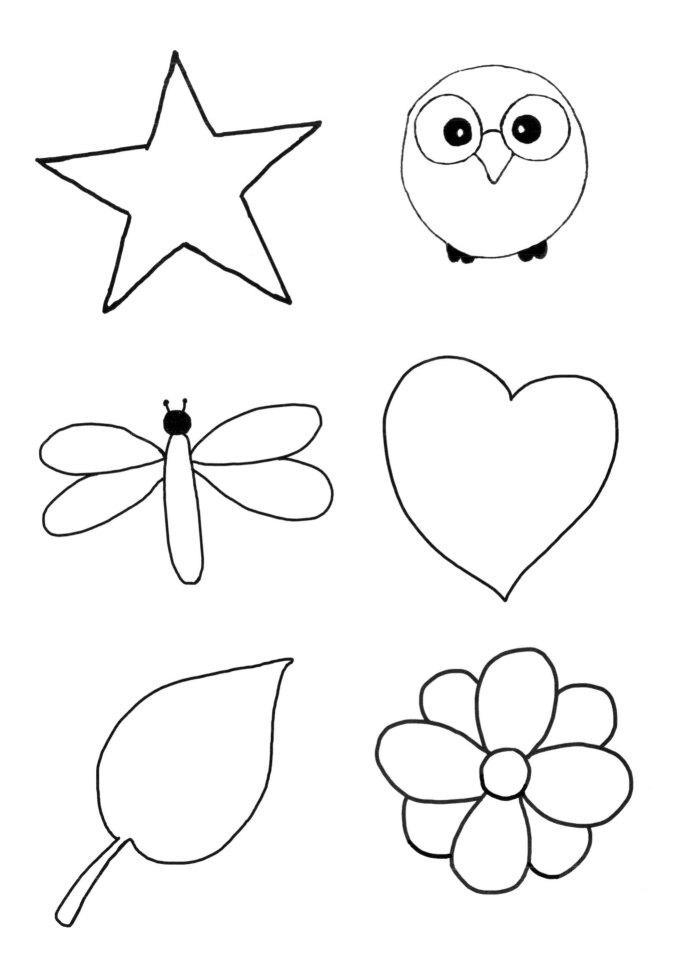

DESIGN WITH QUOTES

On these pages you'll find some great, inspiring ideas just ready to be surrounded with natural beauty. Have fun filling these spaces, then get out a fresh piece of paper to create a whole new design around your own favorite quote or personal mantra.

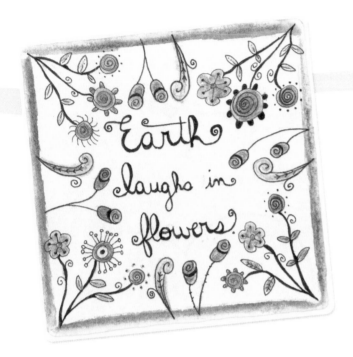

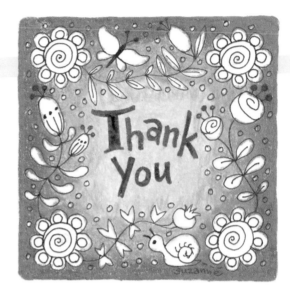

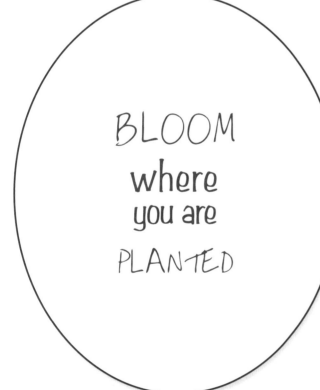

Don´t talk
DO

Make
IT COUNT

DARE *to be*
different

FILL A GARDEN

This is your chance to make the garden you've always dreamt of come true! Whether you don't have the space, the money, or the time for a real garden with all your favorite flowers and plants in it, you can make this garden everything you've ever wanted. Don't forget to add some patterns to the pots and some critters to the scene!

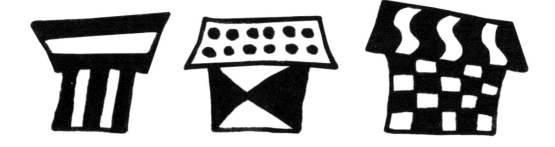

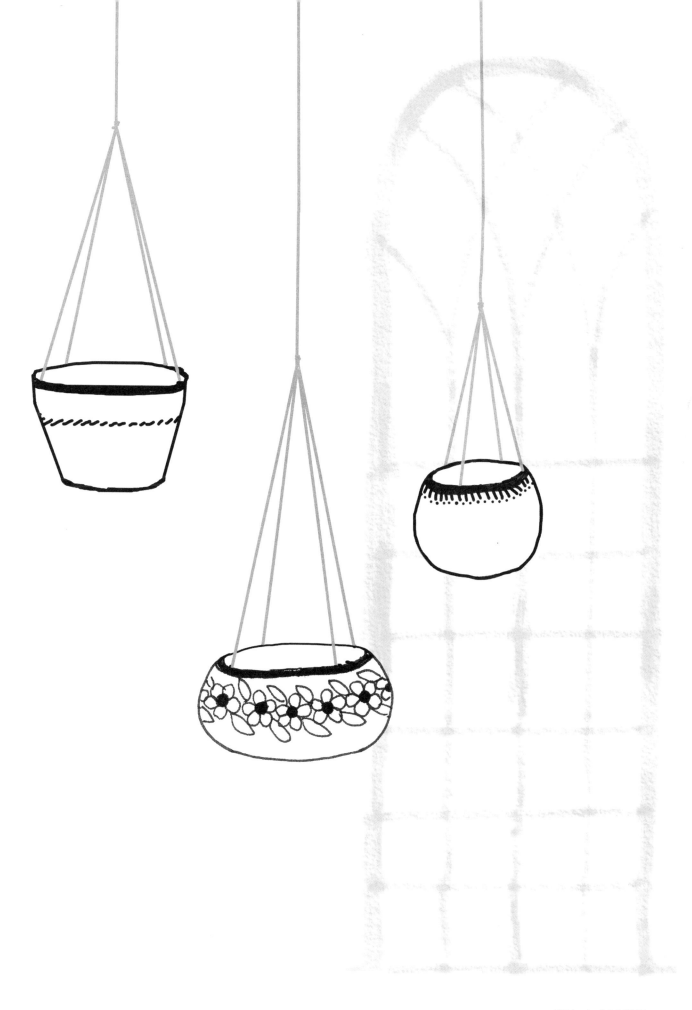

WHITE ON BLACK

You can get a great reverse effect by using a white gel pen on a black background. Try your design on these pages, and then grab some black construction paper if you like what you see! If you want to really make your art pop, add some color with neon and bright gel pens.

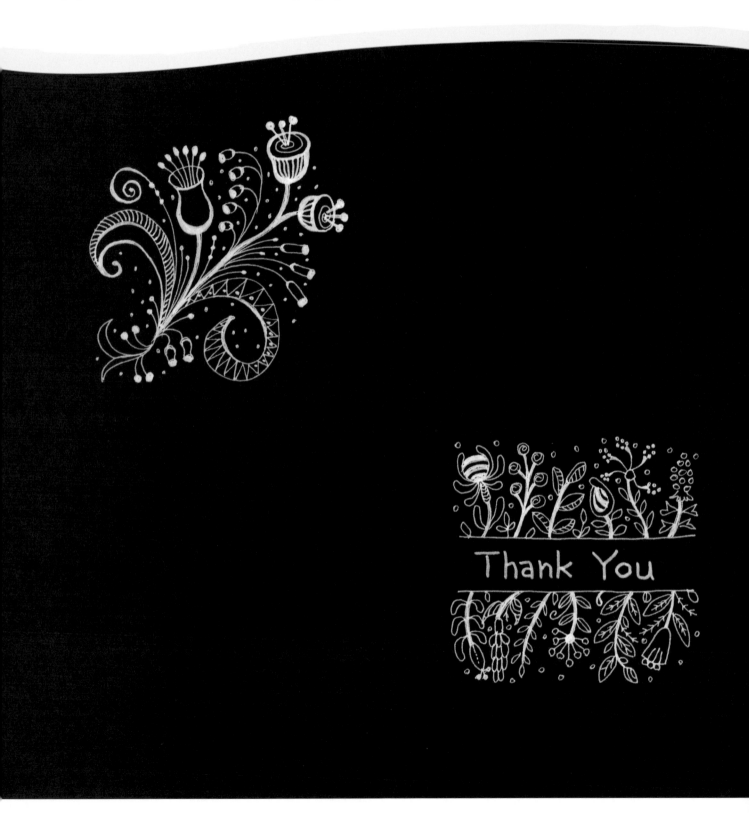

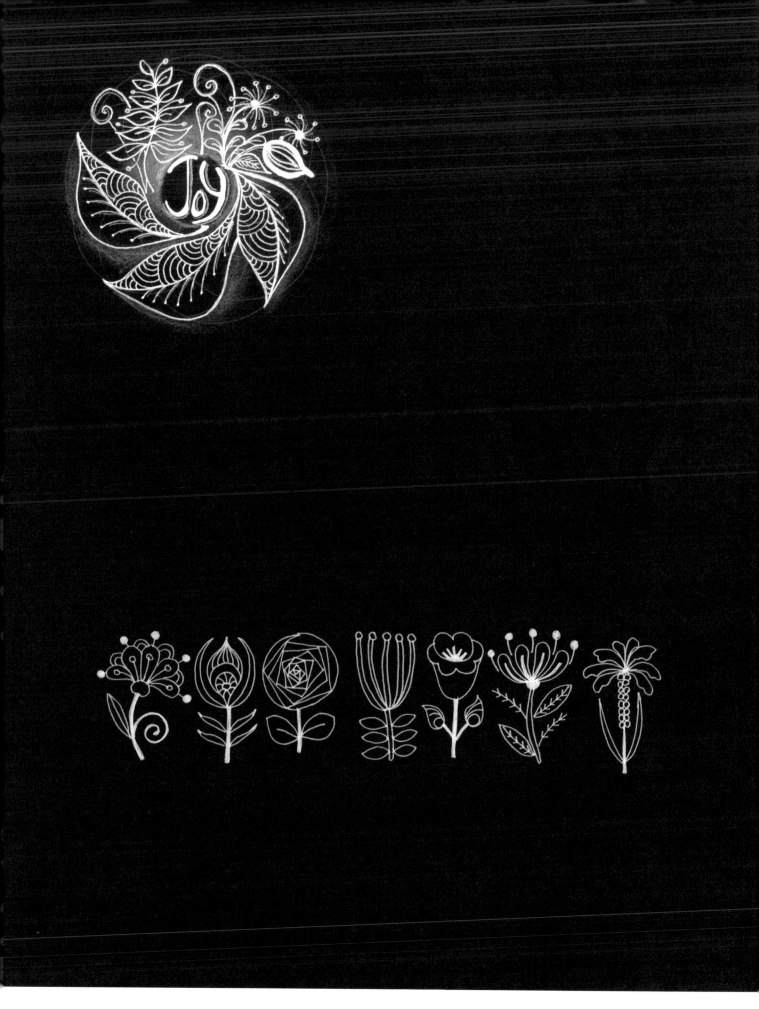

ADD COLOR

Just feel like relaxing? Instead of creating your own composition, just color some of these pieces and get inspired! Try colored pencils, crayons, or markers. Or get really creative and use fun tools like gel pens and watercolor pencils. This is your space to transform black and white designs into glorious color.

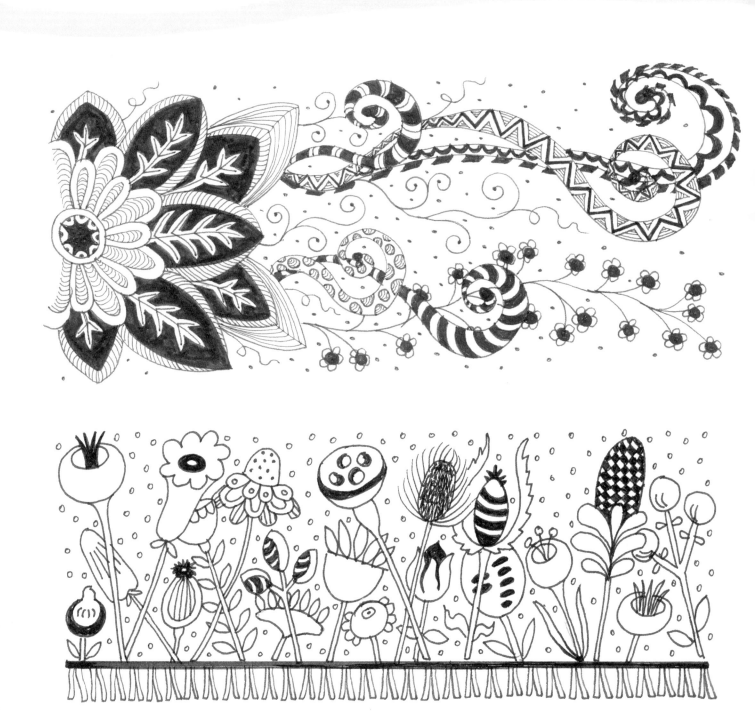

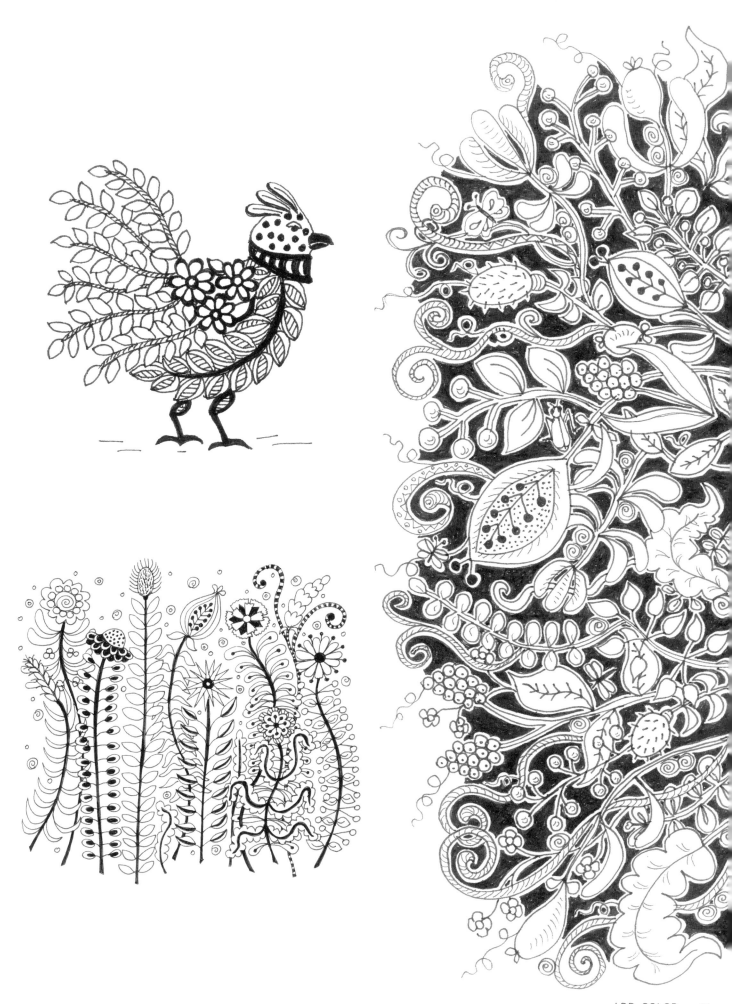

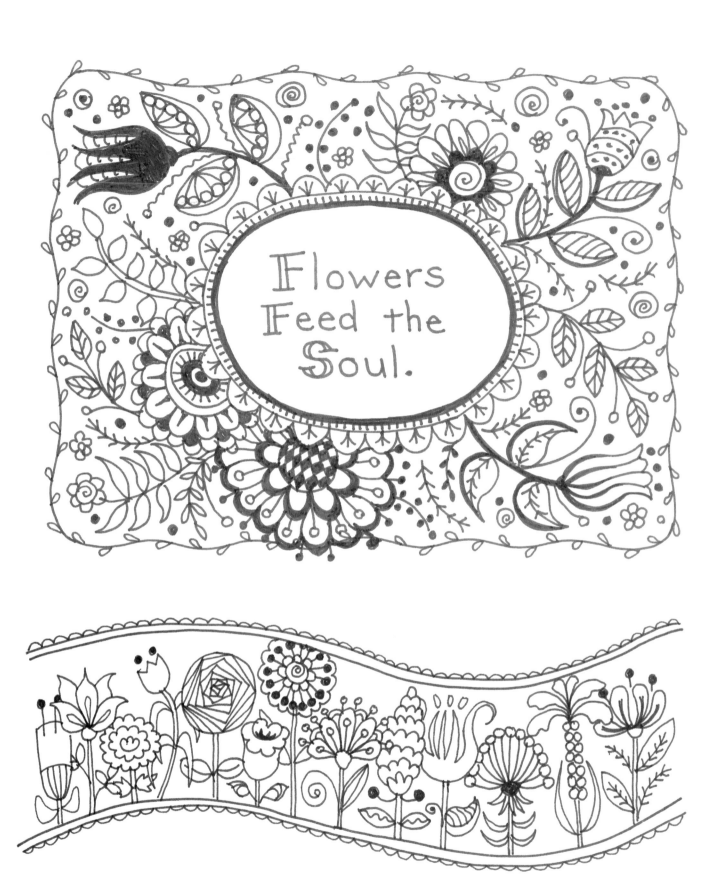

Flowers
Feed the
Soul.

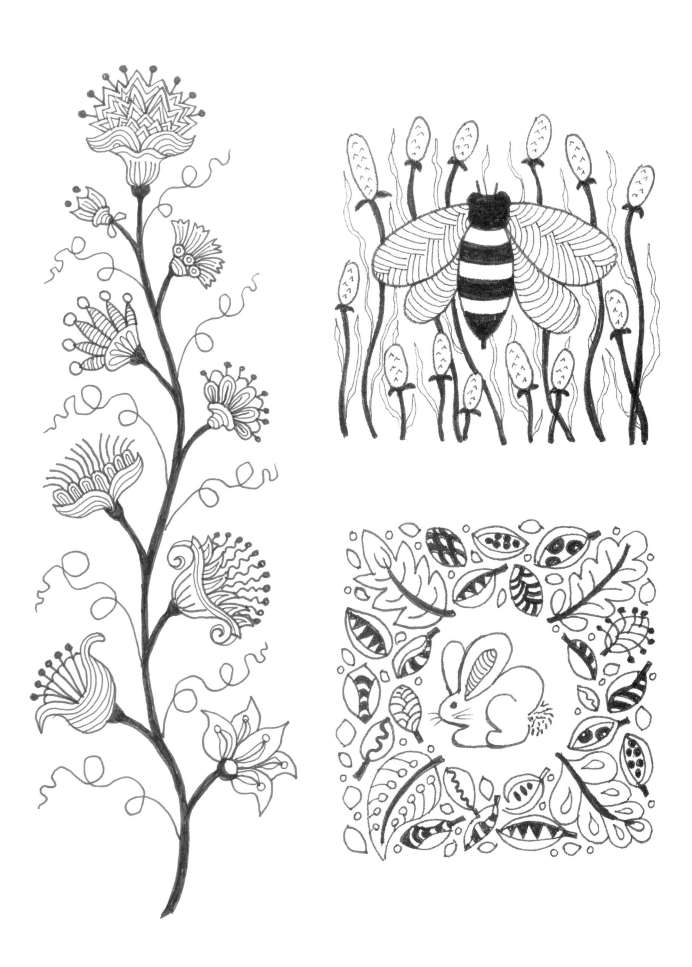

MONOGRAM EMBELLISHMENT

If you liked the monogram featured on page 26, then these pages are perfect for you! They contain some letter outlines for you to fill in with designs. Feel free to design your own letters to fill, too!

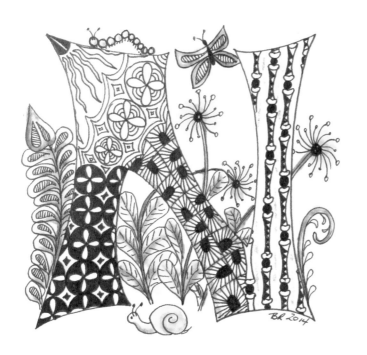

FLORABUNDA BASICS DESIGN
INDEX OF 200+ PATTERNS

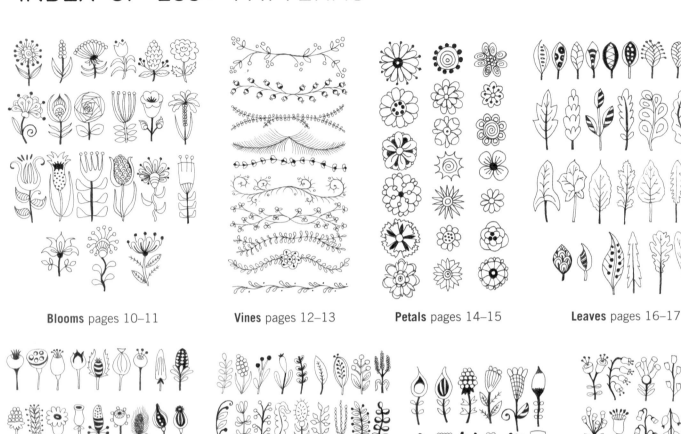

Blooms pages 10–11 **Vines** pages 12–13 **Petals** pages 14–15 **Leaves** pages 16–17

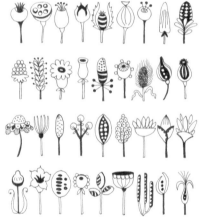

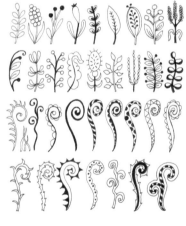

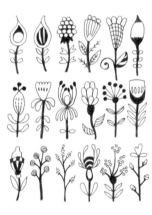

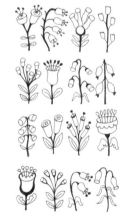

Pods pages 18–19 **Growth** pages 20–21 **Buds** page 22 **Bells** page 23

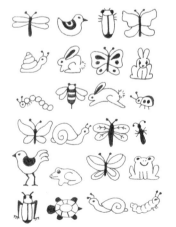

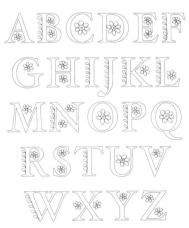

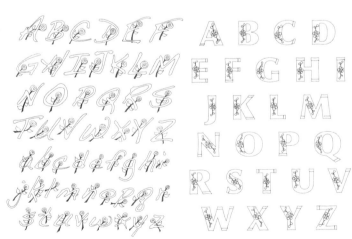

Accents pages 24–25

Letters and Alphabets
pages 26–29